The Courtyard Gardens of Kyoto

京の坪庭

水野克比古

光村推古書院

The Courtyard Gardens of Kyoto

First Printing April 1996
Tenth Printing June 2010
by Mitsumura Suiko Shoin Publishing Co., Ltd.
Kitayama-dori Horikawa higashi-iru
Kita-ku, Kyoto 603-8115 Japan
Author: MIZUNO Katsuhiko
Editor: MATSUKI Kokichi
Publisher: ASANO Yasuhiro
http://www.mitsumura-suiko.co.jp

ISBN978-4-8381-0253-2 C0072

京の坪庭
目次

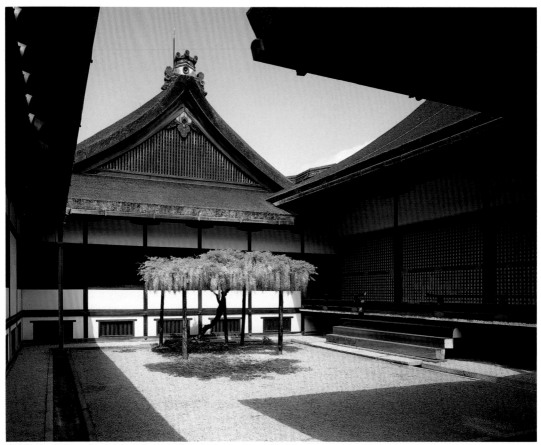

京都御所　藤壺——Kyoto Imperial Palece Wisteria Court

坪庭

　坪庭は建物に囲まれた空間である。その名の源は、平安時代の宮中で寝殿造りの棟と棟とをつなぐ渡り廊下によって仕切られた広い空間を「坪の内」と呼んだことに端を発する。現在の京都御所には、「藤壺」「萩壺」が残っていて、『源氏物語』や『枕草子』に語られる華やかな宮廷生活を偲ばせてくれる。

　時代を経て、鎌倉期には、武士の住居である書院造りに姿を変えて登場し、室町期の禅宗寺院の塔頭においては枯山水庭園として確立する。一方、室町末期に茶の湯が京の町を中心に始まり、桃山期に盛んに行われ、江戸期に完成されるのだが、当時の『山上宗二記』によれば、武野紹鷗の四畳半の茶室に付属した「面坪ノ内」「脇ノ坪ノ内」といった空間地が図示されている。これらの坪空間は後年、茶庭すなわち露地として発展することになる。

　また応仁の乱で荒廃した京の町は、豊臣秀吉によって大改造され、道路を整備、統合したことで町の区画割が長方形の短冊型となり、間口に対して奥行の長い我が国独特の都市家屋が出現する。

　この町家建築で、店の棟と奥の住居の棟との間に坪空間を設けることは、採光、通風上不可欠なことであった。これが町家における坪庭発生のルーツであろう。その空間をさまざまな庭的意匠で楽しむことは、都に住む人々の雅びな美意識と誇りであった。

　デザイン的には、草木だけの自然主義的なもの、禅宗庭園風な枯山水石庭、茶庭的なつくばいを中心に灯籠と踏石を配したものなど多彩である。また常に新しい文化を先取し、受け入れることを好む京都人は、この坪庭においても、モダンな意匠を取り込む努力をいとわなかった。

　そして、庭園において珠玉とまでいえる、坪庭「壺中の天」が今もなお次々と作り出されている。

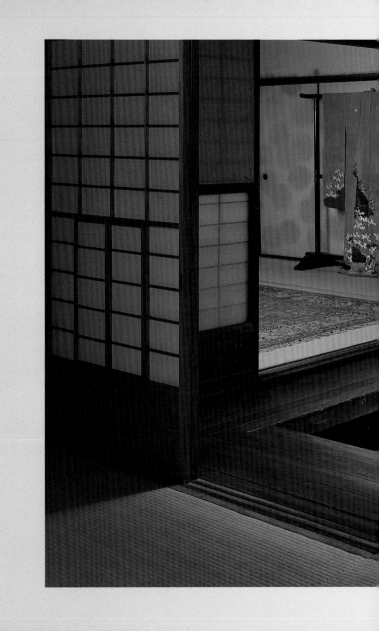

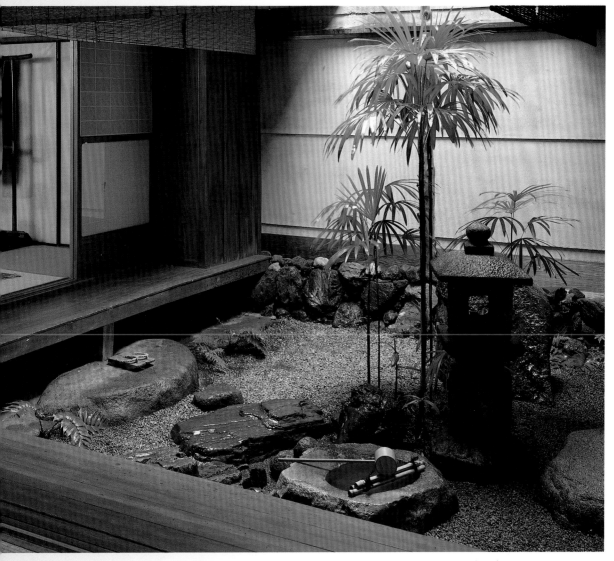

1 吉田家——Yoshida residence

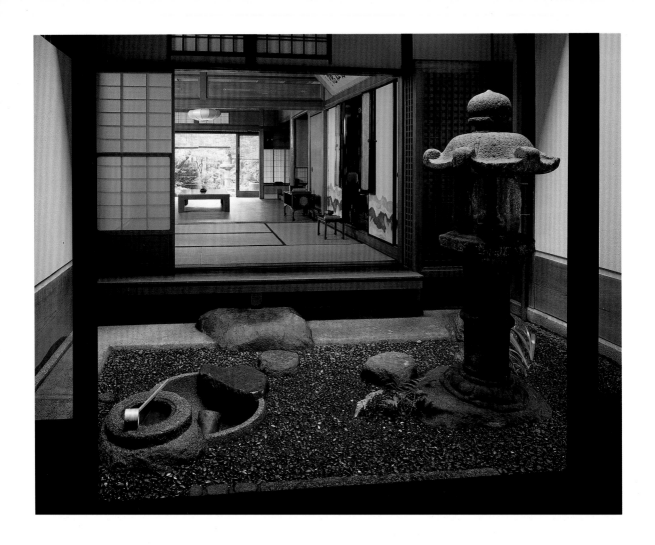

2　池垣家──Ikegaki residence

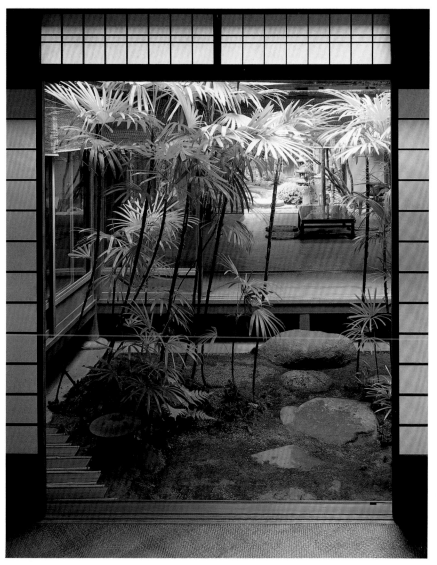

3 野口家——Noguchi residence

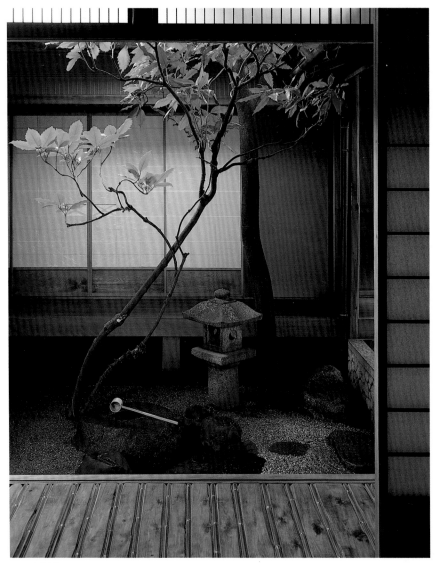

4 久保家——Kubo residence

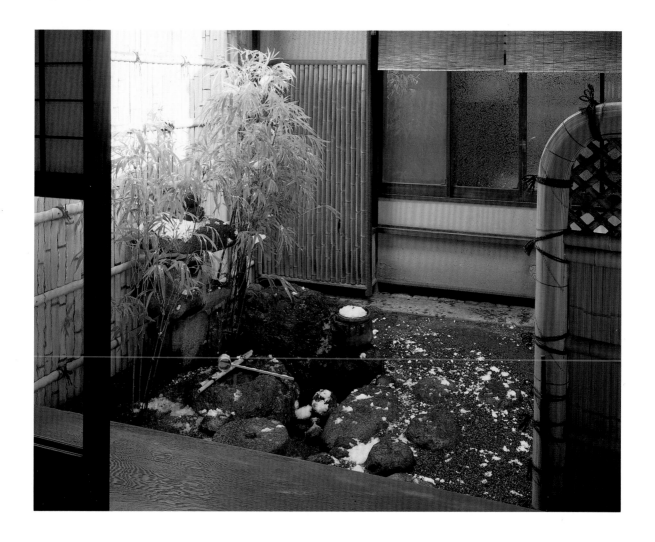

5　深見家───Fukami residence

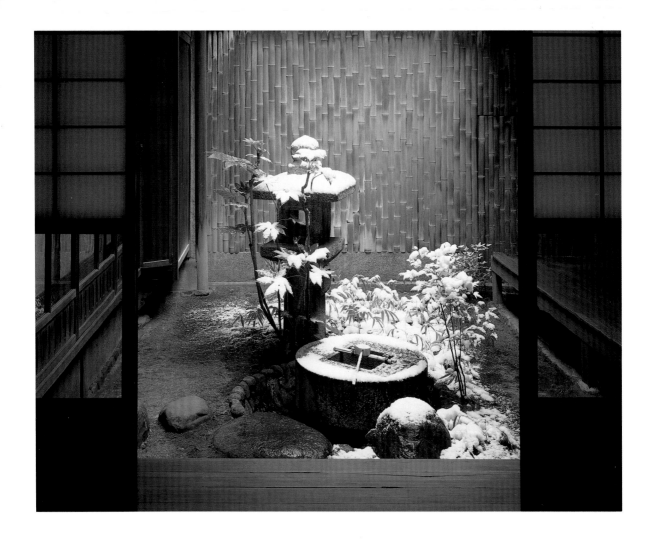

6 　鳥居家——Torii residence

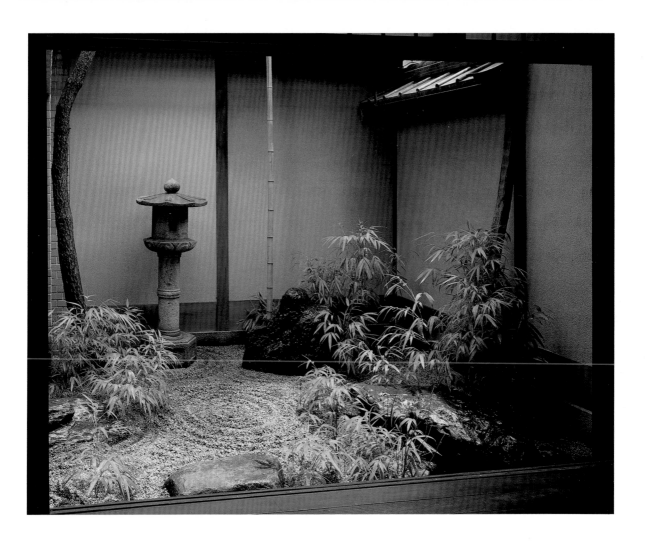

7　加納家——Kano residence

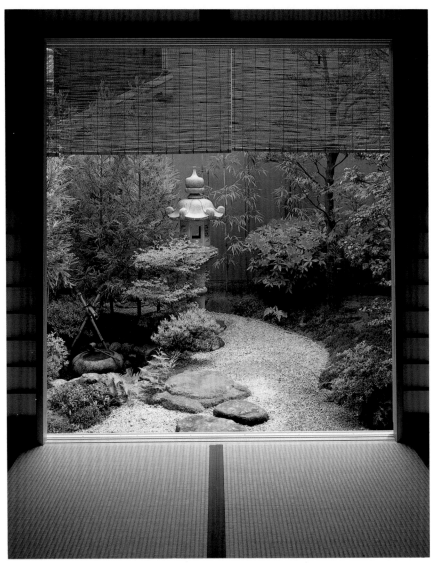

8　松屋——Matsuya doll shop

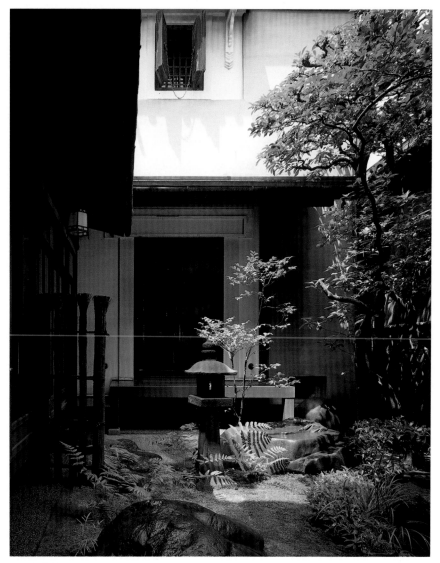

9　藤井家——Fujii residence

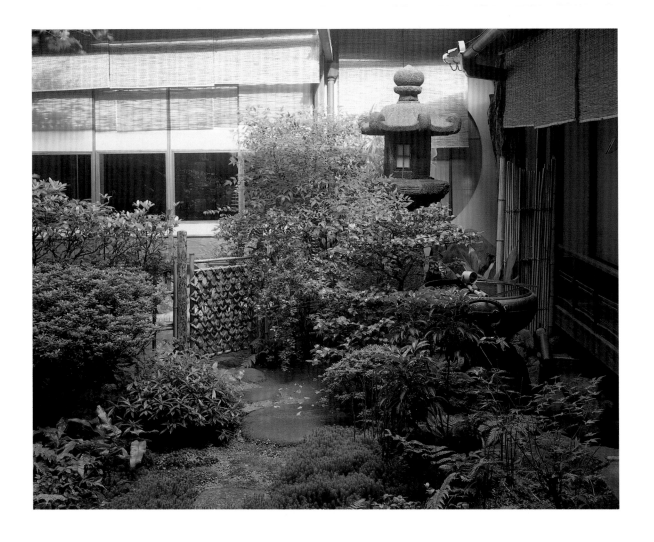

10　田中彌——Tanakaya doll shop

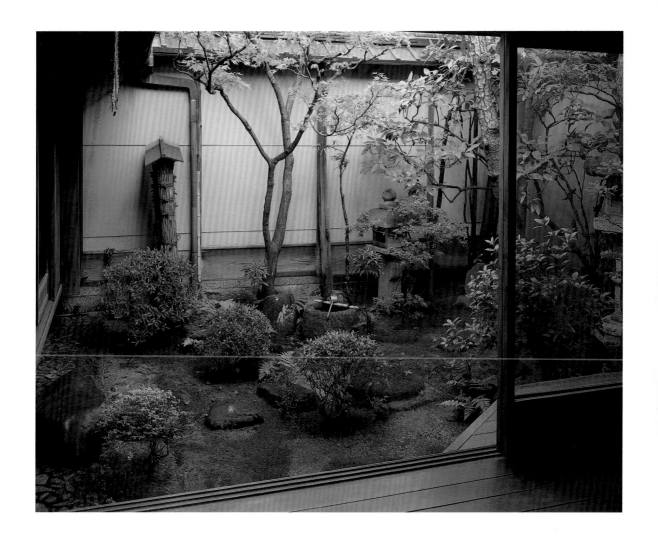

11 宮崎家——Miyazaki residence

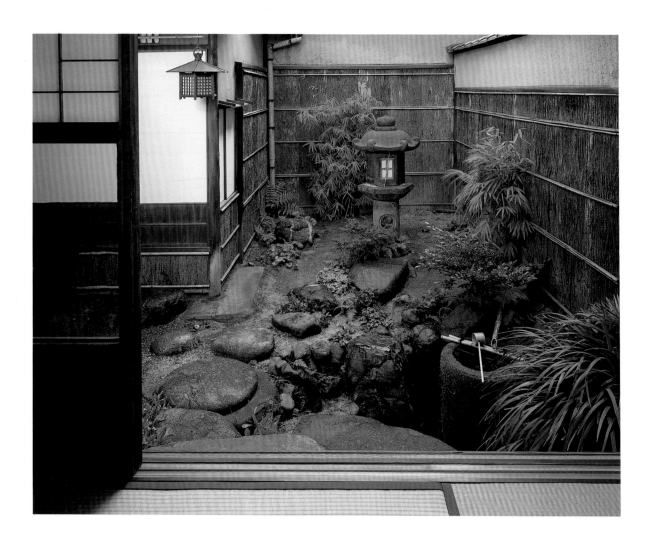

12 木村家——Kimura residence

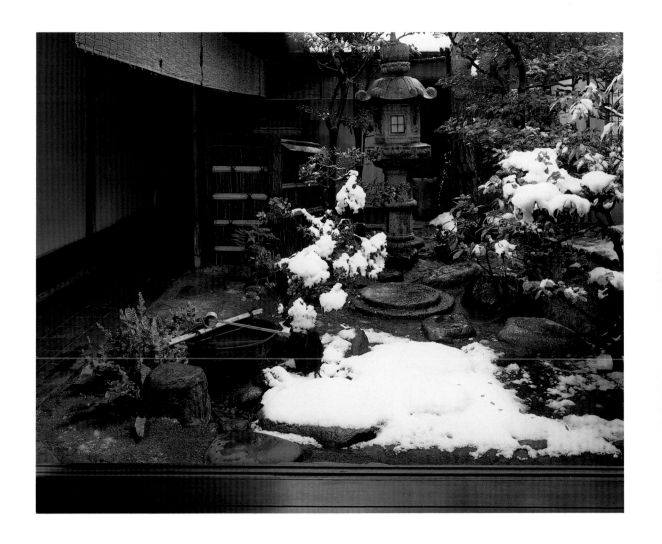

13　井上家──Inoue residence

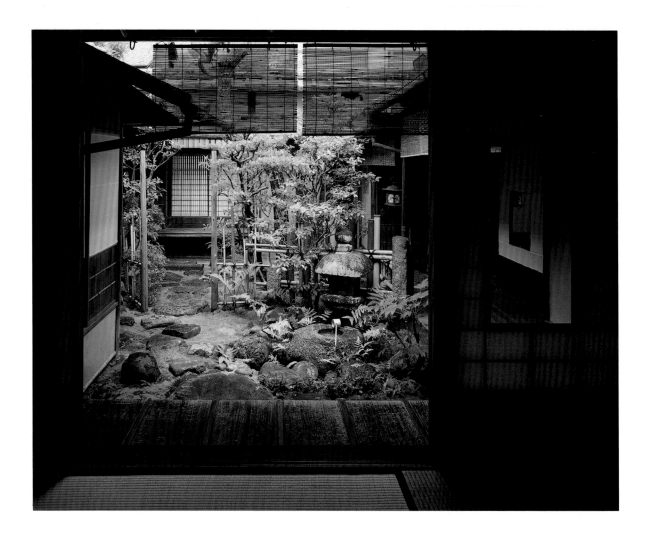

14　山本家——Yamamoto residence

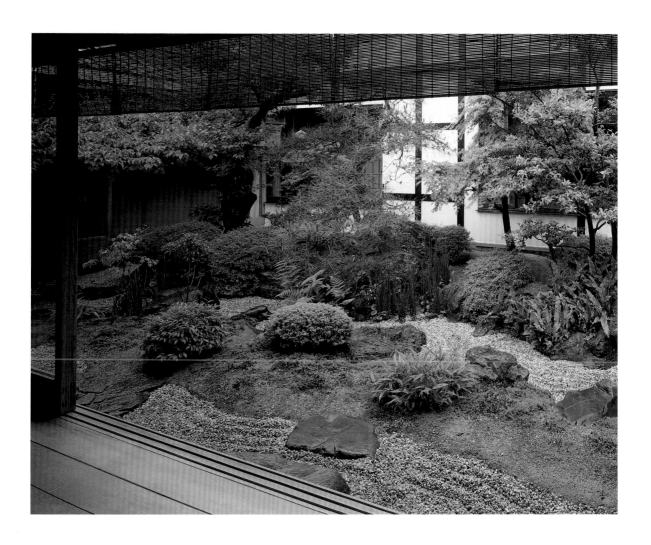

15　北尾家——Kitao residence

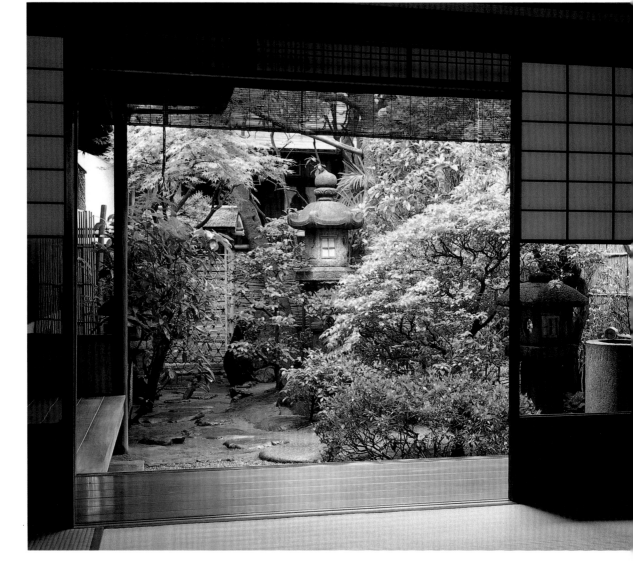

16　巽家——Tatsumi residence

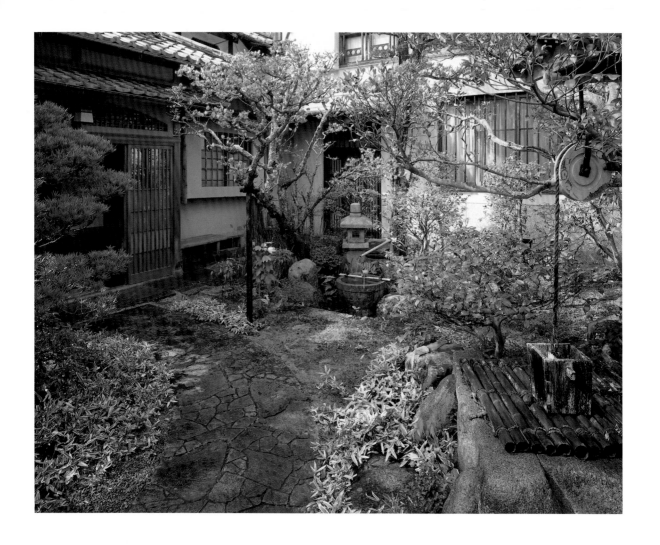

17　伊庭家——Iba residence

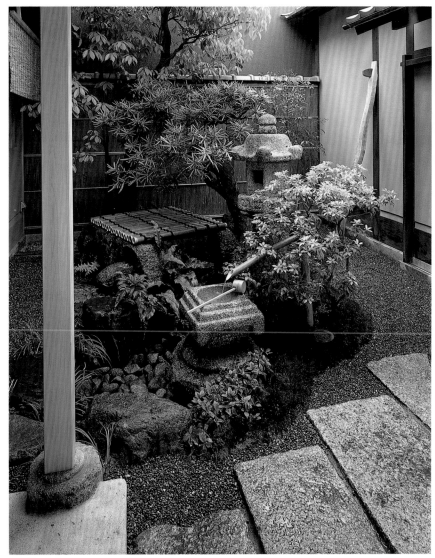

18　伴家——Ban residence

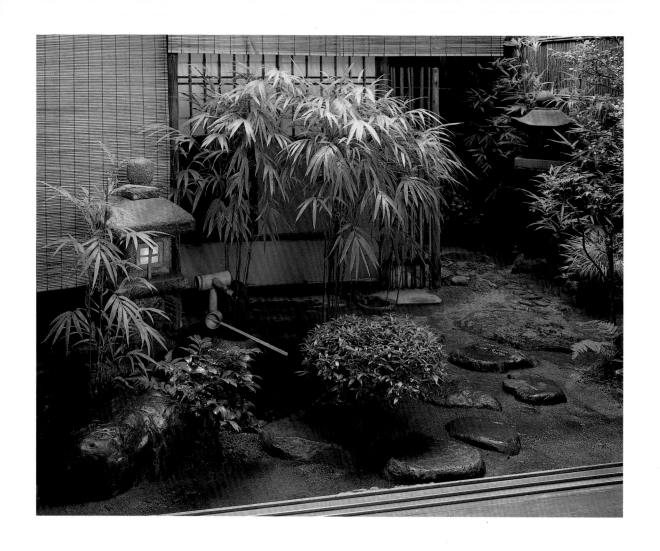

19 泉政——Izumimasa teahouse

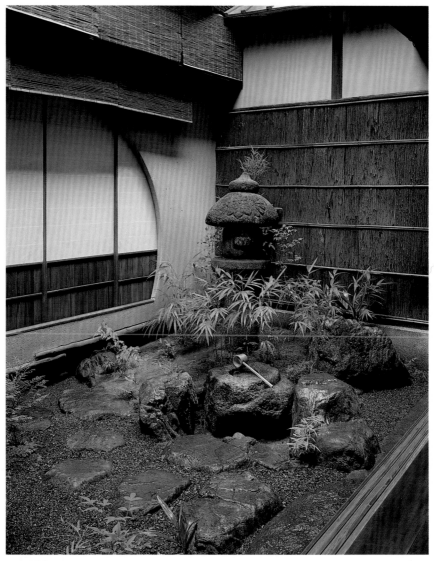

20　三上──Mikami teahouse

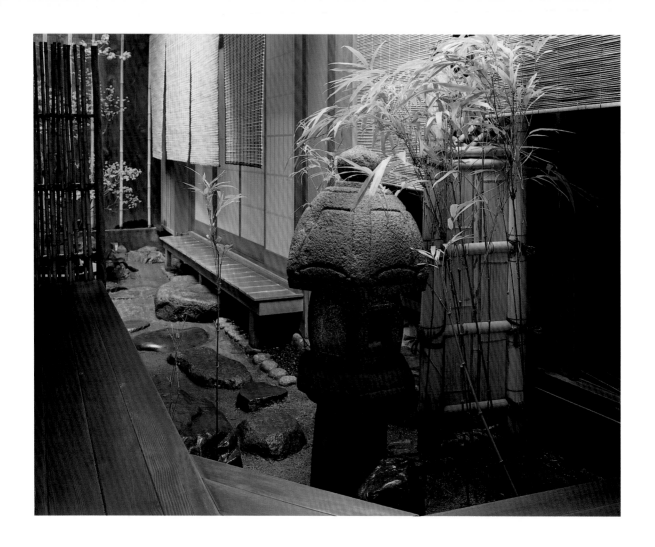

21　備前屋——Bizenya teahouse

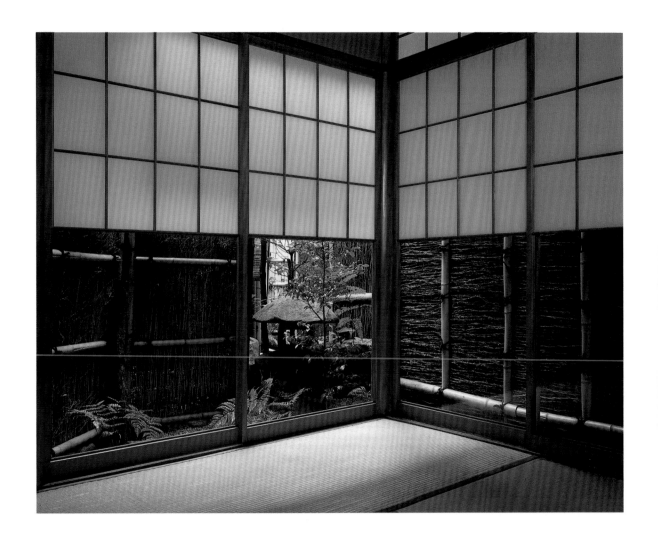

22　大恒——Daitsune teahouse

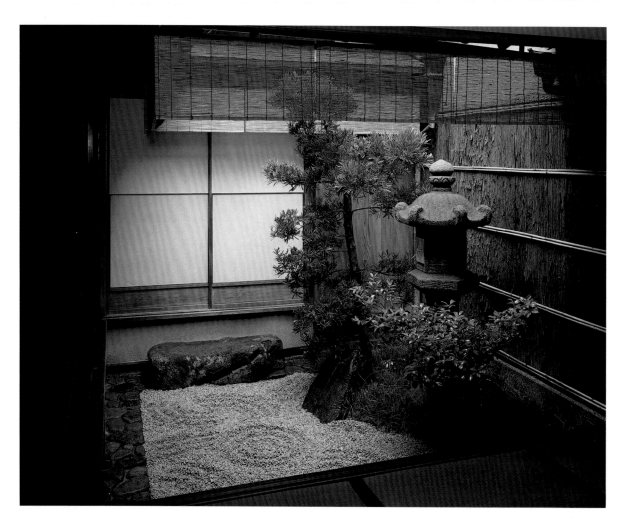

23　廣千代——Hirochiyo teahouse

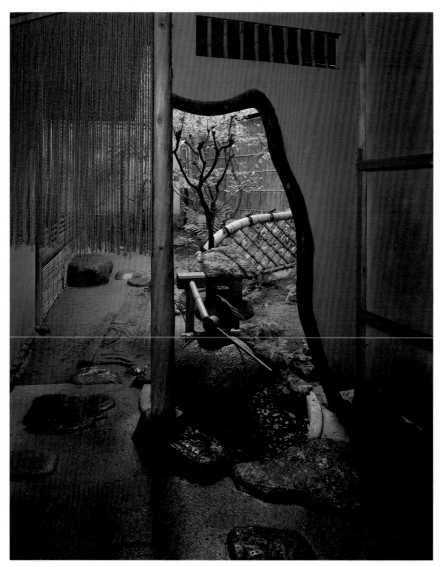

24　中里——Nakazato teahouse

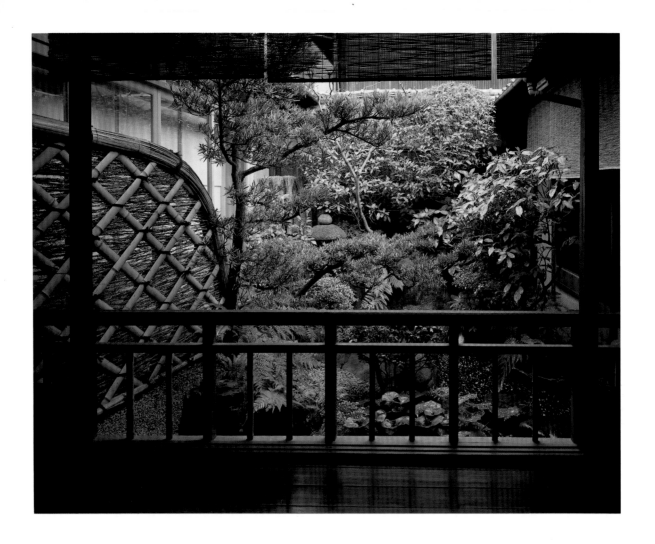

25 萬亀楼——Mankame-ro restaurant

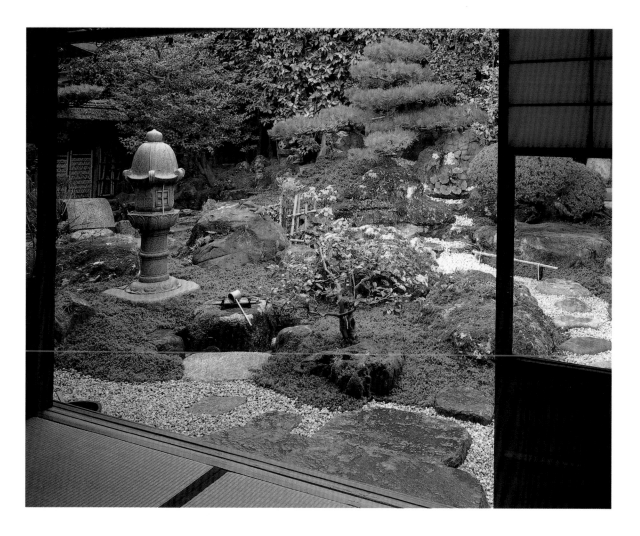

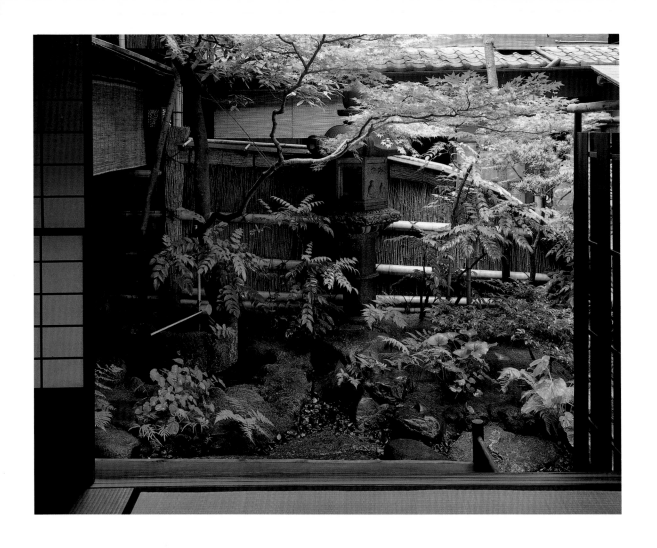

27　炭屋——Sumiya inn

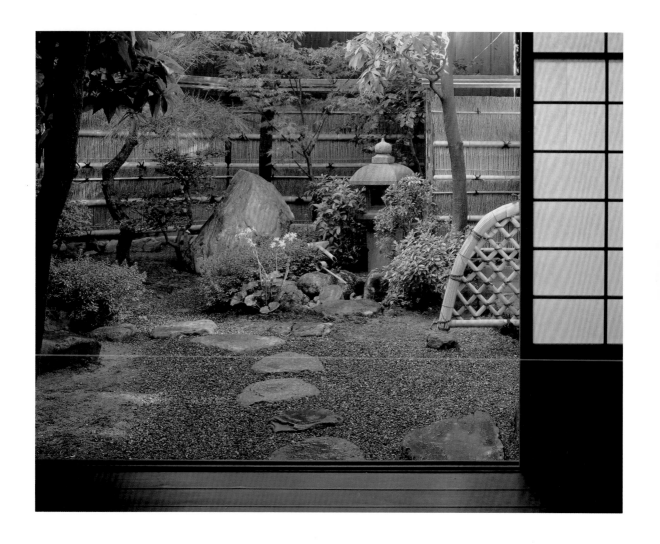

28　近又——Kinmata restaurant

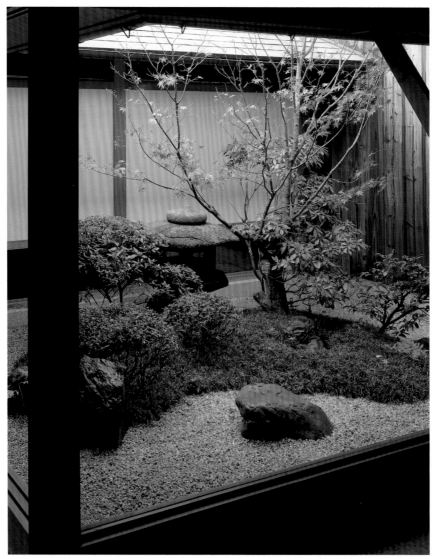

29 月桂冠——Gekkeikan sake CO.,LTD.

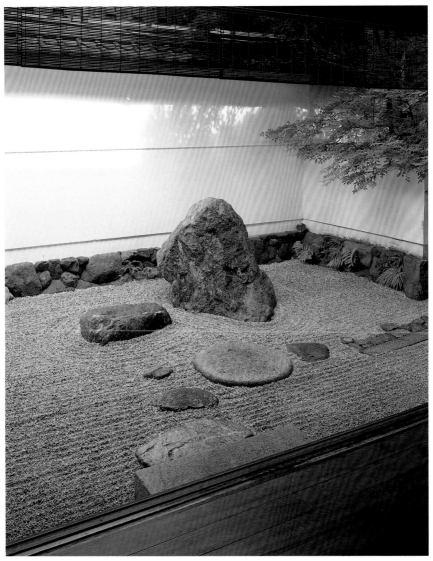

30　枡梅——Masuume teahouse

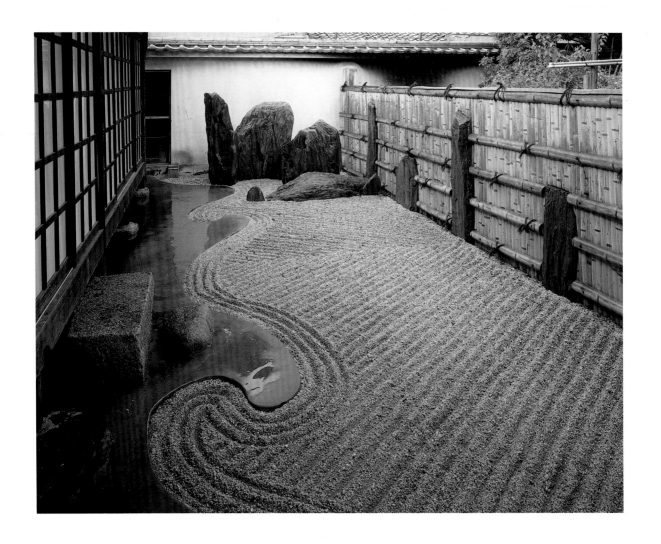

31　重森家──Shigemori residence

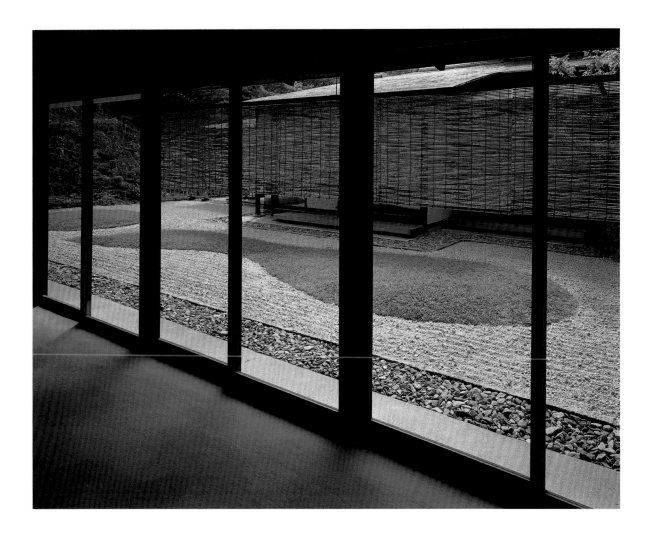

32　都ホテル——Miyako hotel

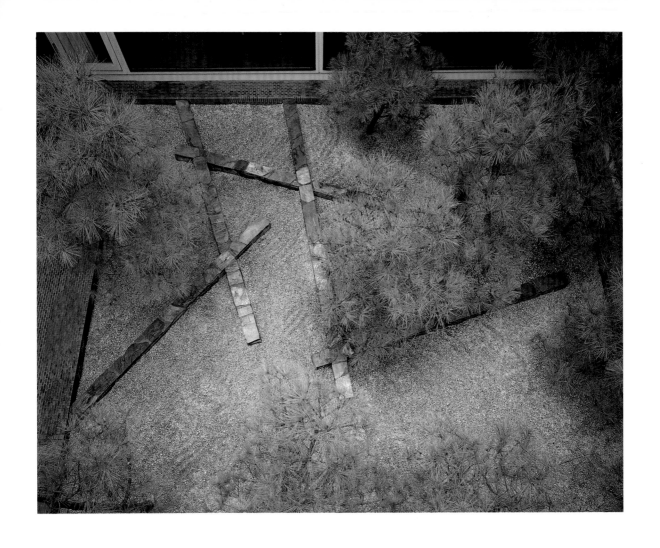

33　京都信用金庫北山支店──Kyoto Credit Union, Kitayama branch

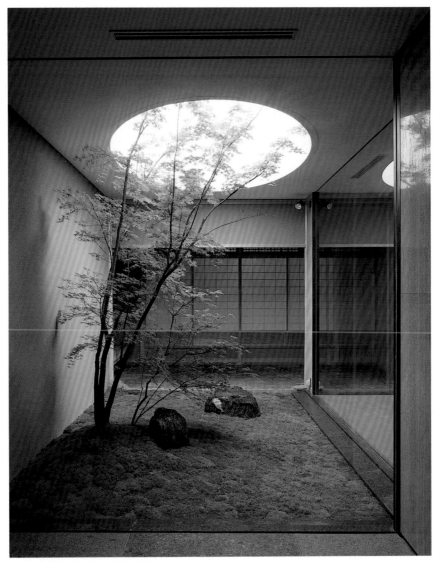

34　何必館・京都現代美術館——Kahitsukan／Kyoto Museum of Contemporary Art

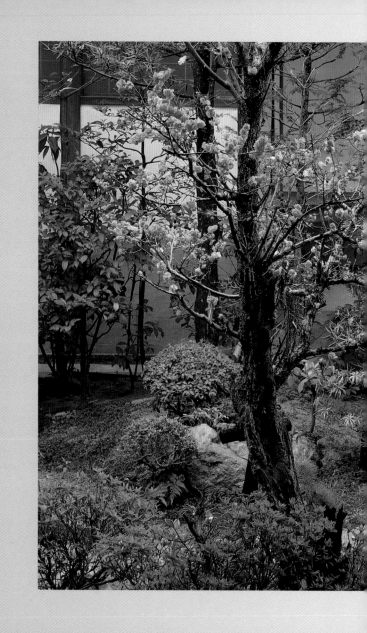

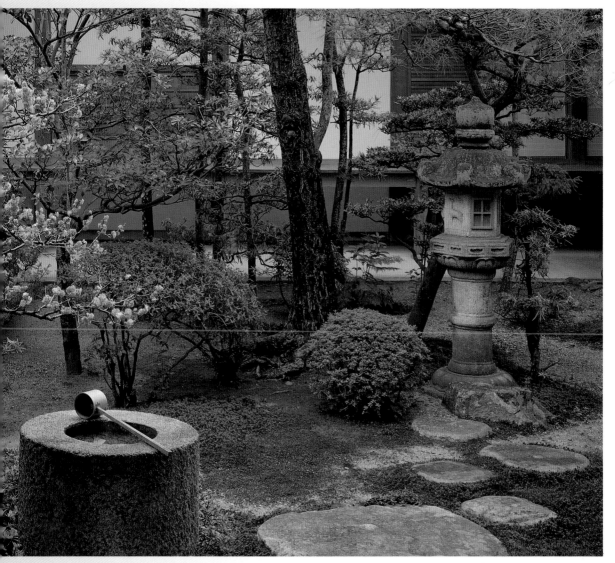

35 南陽院――Nanyo-in temple

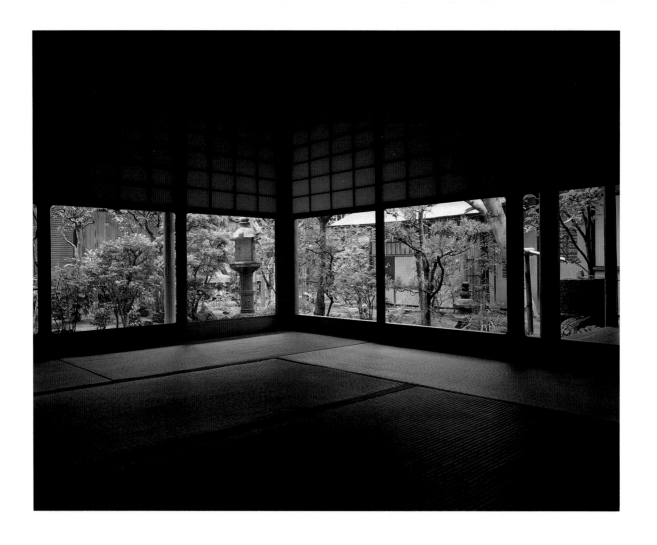

36　興臨院──Korin-in temple

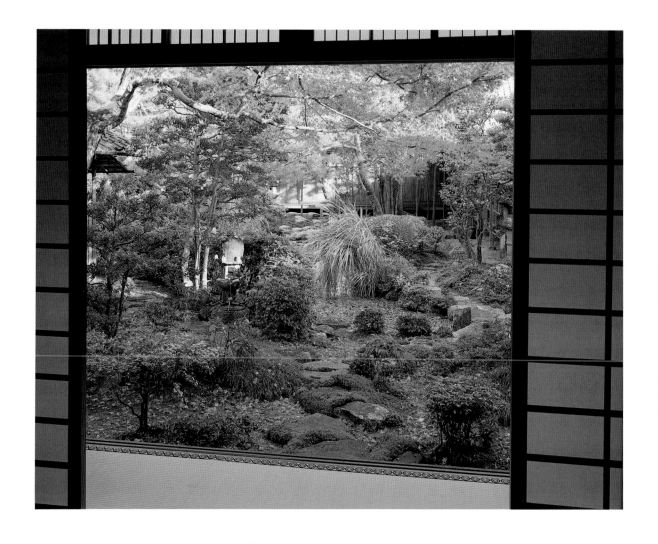

37 法然院——Honen-in temple

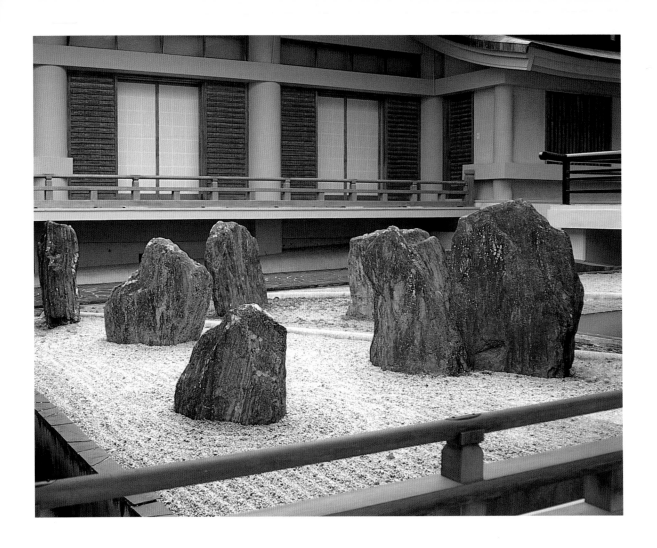

38　松尾大社──Matsuo-taisha shrine

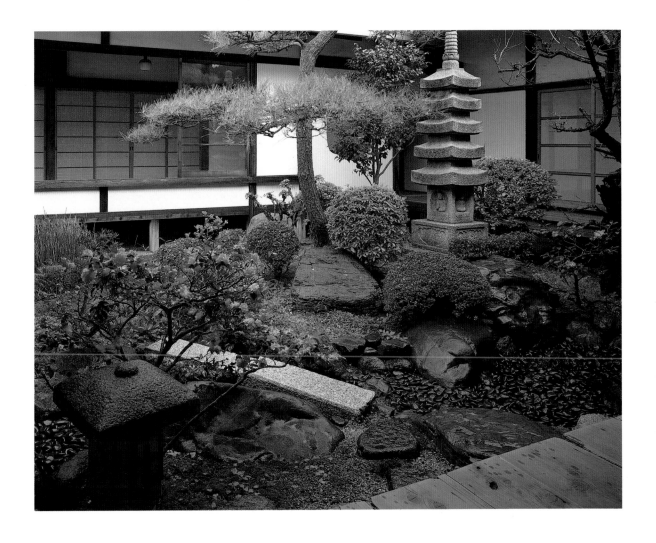

39　妙蓮寺——Myoren-ji temple

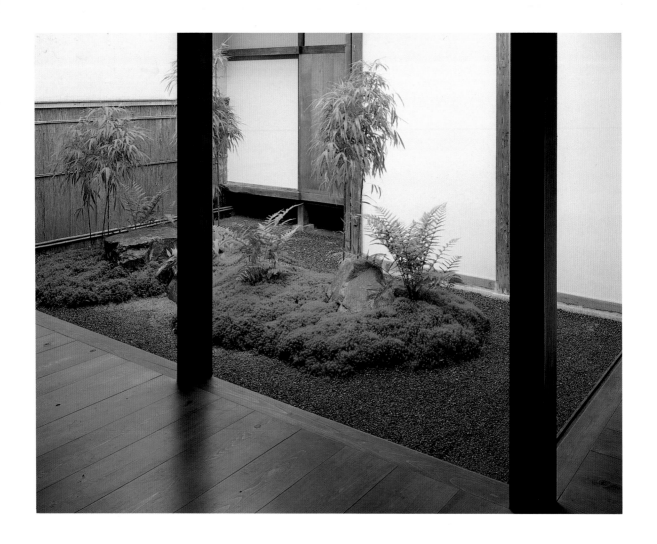

40　三千院——Sanzen-in temple

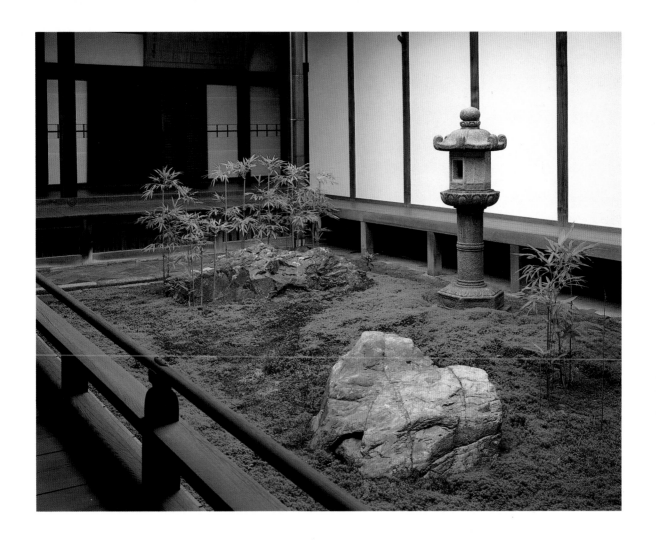

41　大徳寺本坊——Daitoku-ji temple

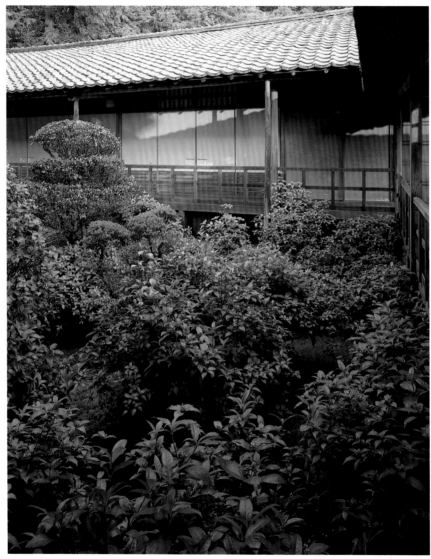

42　安楽寺——Anraku-ji temple

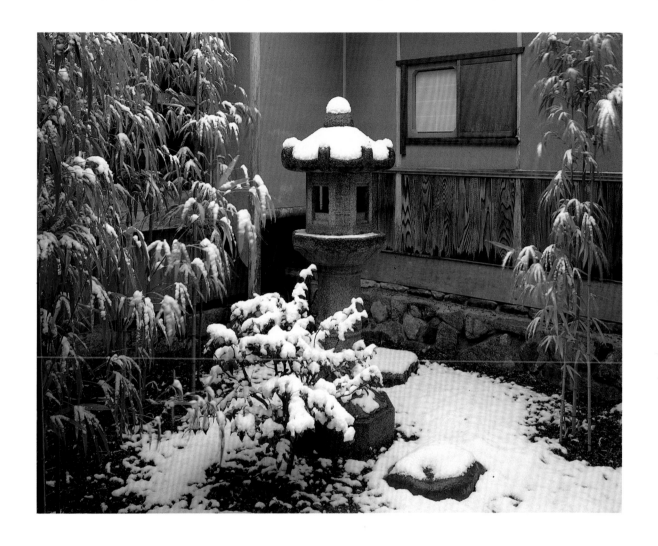

43 宝泉院——Hosen-in temple

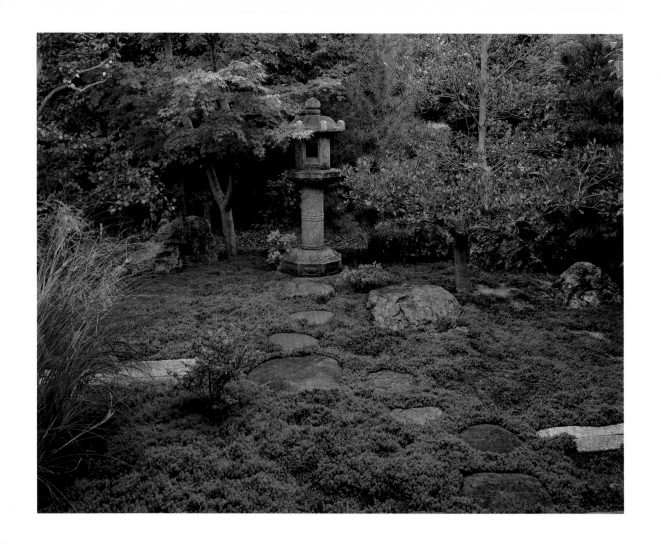

44　曇華院——Donge-in temple

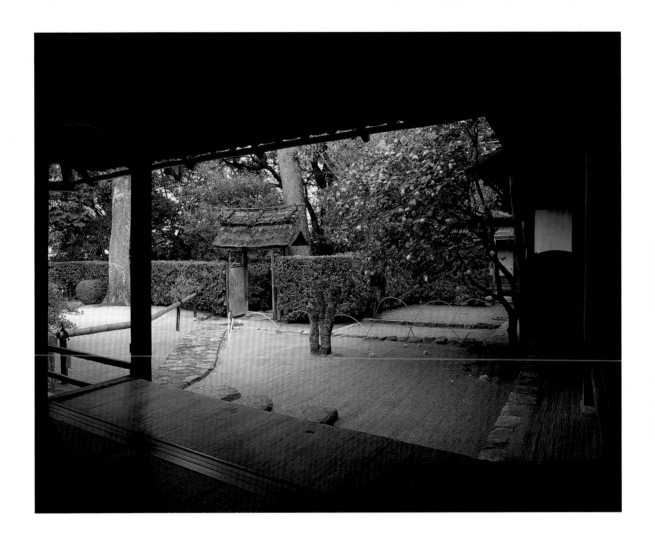

45 詩仙堂丈山寺──Shisendojozan-ji temple

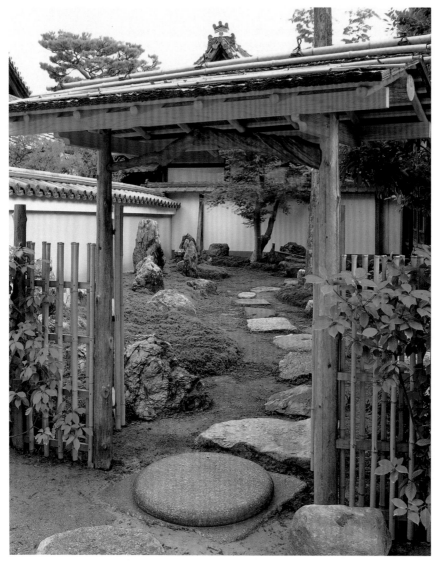

46　高台寺——Kodai-ji temple

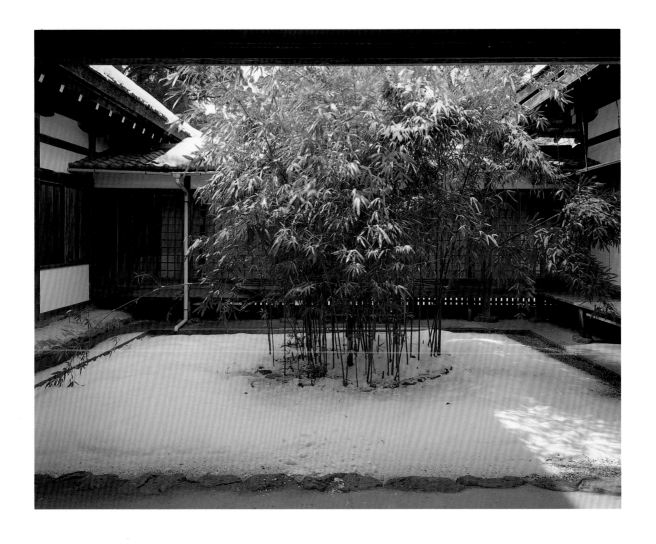

47　上賀茂神社——Kamigamo-jinja shrine

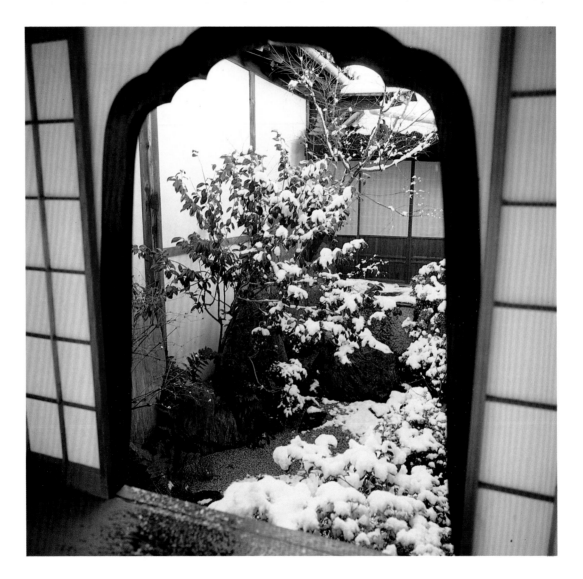

48　桂春院——Keishun-in temple

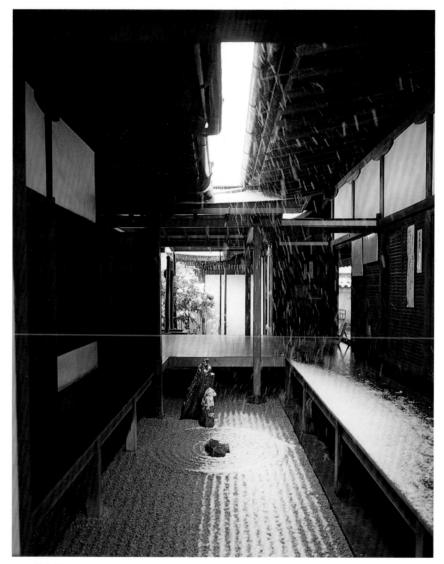

49　龍源院──Ryogen-in temple

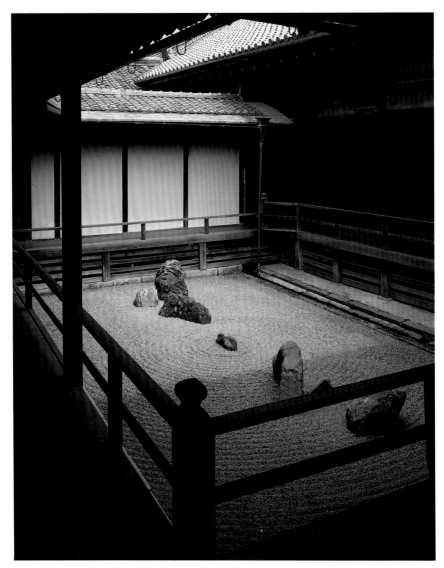

50　東海庵──Toukai-an temple

あとがき

　坪庭は、都市における日々の暮らしの中に、四季の自然を呼び込んでくれる。

　初夏には簾ごしに、微風が陽光を連れて流れ込み、秋には、時雨の後の夕暮どき、灯籠の灯火が懐かしい。小鳥たちが連れだってやって来る夏の朝。深々と冷え込む夜、雪見障子の向こうに、雪が降り積もる立春の頃。柔らかく重い京の雪は、木々を草を踏石を、そしてつくばいをも、見る見る覆い隠し、その小さな空間は天に向かって無限に広がっていく。

　寺社の重厚な建物に深く囲まれ、また「うなぎの寝床」と呼ばれる町家の中にあって、通気と採光の優れた機能性と合理性を発揮しながら、同時に生活に限りない潤いをもたらしてくれる坪庭は、京に住む人々の知恵と美意識によって完成された一つの素晴しい庭園様式であろう。

　今日見直されつつある野性生物の生息する空間、すなわち「ビオトープ」やそして「イングリッシュガーデン」と同じ理念の上に立って、都市の空間に自然の環境を取り入れ、植物や小動物たちと共存しようという試みこそ、古くから人々が慈しみ、磨き上げてきた坪庭そのものではないだろうか。

　自然と切り離された日々の生活に疲れきった現代人にとって、ぎりぎりの選択として残された居住空間改善への鍵が、こんなにも永い歴史を持って身近に存在していたことを考えると嬉しくなる。たとえ池泉を伴った舟遊式や回遊式の大庭園であろうと、一木一草一石の小庭園であろうと、その心は同じであると思う。

The Courtyard Gardens of Kyoto

by

Preston L. Houser

To William and Bonnie Houser, my parents

The Courtyard Gardens of Kyoto

I BEGINNINGS

> Through the unknown, remembered gate
> When the last of earth left to discover
> Is that which was the beginning
>
> ——T. S. Eliot

The Japanese courtyard garden represents a beginning of sorts. Named for its size, the *tsubo-niwa*, as it is known in Japanese, is a small, interior garden which plays a significant role in the ideal Japanese home. At first glance, the courtyard garden is easily describable: within a small area, usually no more than two meters square, the garden enacts a variation on the themes of stone and plant, grey and green, hard and soft, horizontal and vertical. And, when properly perceived, we do indeed discover that we stand at the threshold of a beginning which we thought was an end, and contemplate a revelation which we thought was memory.

Scholarship in the arts and sciences is largely a matter of recognizing patterns and making connections. The same is true of the garden, which simultaneously functions two dimensionally (like a painting) and three dimensionally (like a sculpture), and requires a multi-level appreciation in the viewer. As we *participate* in a garden, we begin to see there are patterns in us, both as individuals and as parts of the larger

communities to which we belong.

Borrowing heavily from ancient Chinese urban planning during the Heian period (794-1185), the capital of Japan, Kyoto, was deliberately laid out on a grid emulating the pattern of the then capital of China, Chang-an (today Xi'an). For nearly a thousand years, Kyoto dominated Japanese politics and culture. The city itself, home to a sophisticated aristocracy, was seen as something akin to a garden where culture was allowed to flourish. During the sixteenth century as the unification of the country was underway, Kyoto became a symbol of the "garden of Japanese culture" as well as a metaphor for a larger garden the country strived to become.

Like the British archipelago, Japan underwent an extended enclosure process between 1500 and 1880. For both England and Japan, this centuries-long system involved the fencing of open range into parcels of land. Vast tracts of country which once belonged in the public domain were slowly divided into strictly measured portions. There were certain agricultural and economic advantages to be gained from enclosure, to be sure, yet, at the time, such a novel concept as the partitioning of public land was utterly preposterous.

Today, of course, we've grown accustomed to the compartmentalization of nature—wilderness seems to be consigned to "national parks," or consumed into an ever-spreading, ubiquitous, ambiguous, "civilization." Politically, the garden has become a ramification inherited from the enclosure system, the slow-moving subjugation of wilderness. Indeed, as the example of courtyard gardens illustrates, the house surrounds the garden, effectively enveloping it from the larger wilderness outside. The garden is like a wild animal we have temporarily tamed, like—perhaps over-optimistically—the savage aspect of our society.

II THE EXTERNAL GARDEN

The courtyard garden, as an evolutionary art form, tends to combine symbols, patterns, forms, and ways of seeing. Outwardly, the gardens seem to aspire to an apotheosis of simplicity, utilizing the essentials of stone and tree, or the equivalents of gravel, sand, and moss. As we see in the photographs, the elements of a courtyard garden are arranged seemingly at random, without order, and yet we seem to thrive on the garden's asymmetry. The image of simplicity, however, is a deceiving one; it is an ideal which the beginning or novice gardener, and viewer for that matter, tends to impose on the garden. Experience, on the other hand, continually shows us that life (and the symbolic representations we employ to make sense of nature's inherent chaos) is anything but simple. To the cultivated eye, these courtyard gardens are capable of containing multitudes of images, mythologies, personalities, and cultures. The courtyard garden presents the viewer with a psychological wall on which one can inscribe spontaneous, spiritual graffiti.

The basic components are always present in the courtyard garden: stone, water, greenery, and an often indistinct source of light. Occasionally a flower in bloom, or stepping stones, or a bamboo fence accentuate the garden scene. Stone lanterns figure prominently in courtyard gardens but, while they sometimes house a flame, their function is mostly figurative. They are there to offer symbolic light along our troubled way through the world of samsara, cause and effect, birth and death.

Garden designer Marc Keane points out, in his landmark treatise *Japanese Garden Design*, that courtyard gardens evolved from the *shinden* architectural style of

the Heian period (based on a central main room of the house joined by roofed corridors to extraneous antechambers), and then later during the Edo period (1600-1868) to the development of the *machiya* or townhouse style of residential design. The gardens enclosed by these homes (and in some cases palaces and temples), Keane continues, were often named after the plant they hosted, for example, wisteria garden (*fuji-tsubo*) or paulownia garden (*kiri-tsubo*).

This product of a developing Japanese architecture, the courtyard garden seemed to fill an urban need, a need for an illusion of expanse in the face of a contracting society. As Indian writer Rabindranath Tagore pointed out at the beginning of the century, "the home and the world" are separate universes, the chasm between them ever widening, exacerbated by an increasing sense of psychological alienation. The courtyard garden, therefore, is something like a peaceful sanctuary, a tranquil eye in a social hurricane.

Although the courtyard garden, like most contemporary Japanese arts, had noble beginnings connected to imperial palaces, country villas, or Buddhist temples, what we recognize today as the courtyard garden is more than just the outcome of an evolutionary architecture; the garden seems to absorb the best of Japanese culture. Japanese arts cross pollinate. One art informs, influences, and changes another in a never-ending process of cultural modification, so that a certain style of flower arrangement will influence the tea room, a tea ceremony properly executed will in turn enhance our appreciation of the garden, and so forth. If there is one solid rule concerning the appreciation of Japanese arts it is this: When we better appreciate one art form, we acquire a better understanding all the others.

A close cousin of the courtyard garden is the tea garden (*roji* in Japanese which

poetically refers to the "dewy ground" surrounding the *chashitsu* or tea room) an indispensable component to the tea ceremony (*sado* or *cha-no-yu* in Japanese). Indeed, courtyard gardens are often perceived as private tea gardens, prompting many makers of courtyard gardens to insert allusions to the world of tea into the garden environment. The *tsukubai*, for example, is the general area of the garden reserved for rinsing one's hands prior to a tea ceremony, as well as the place for gathering water to be used for tea. Since the word *tsukubau* means "to crouch" (in a gesture of humility), the water area of the garden is often a sunken site, or at least an area one must step down to before stooping further to gather water or to rinse one's hands. A stone water basin (*chozobachi*), a stone lantern (*ishidoro*), a bamboo tea ladle (*tsukubai-bishaku*)—tea apparatus often accentuate the garden like ornaments, providing an artistic context to the scene. Occasionally, the water source for the basin is detectable, usually as a straight piece of bamboo plumbing. (Closer inspection of the stone lantern and basin in the garden setting suggests a sexual imagery: the chozobachi representative of the female principle, while the ishidoro a phallic counterpart. Scholars of traditional Hindu art, for example, will instantly recognize the lingam and yoni stones which complement and complete the fecund garden scene.)

Given the meditative quality of the garden experience, it is inevitable that tea and Zen Buddhist aesthetics would influence garden construction. The cult of tea, along with Zen Buddhism, entered Japanese culture during the seventh century and eventually reinforced and sustained developing samurai tastes. Efforts to combine tea and Zen Buddhism into a symbiotic cultural activity seemed natural, and yet such coupling of refinements has not been as successful as many tea masters had originally hoped (especially artist and Zen priest Ikkyu). Arts associated with Zen and tea stress

simplicity, however, that is where the similarity ends. Arguably the world of tea is diametrically opposed to the world of Zen: the former seeks to construct an elaborate world based on voluptuous aesthetic values, the latter seeks to strip the world to austere essentials. Tea struggles to manage an over-abundance of sophisticated significance; while Zen recognizes the inherent emptiness of existence. The tea ceremony represents cultural ideology at it's most indulgent; Zen is hyper-materialism which in many ways shuns the pretentious trappings of "culcha" as so much dust. After careful consideration, the world's of tea and Zen appear to be mutually exclusive in their spiritual and aesthetic goals.

III THE INTERNAL GARDEN

The courtyard garden is a symbol of absence as much as a portraiture of presence. It can be many things to the viewer simultaneously. A sandbox, a pool, a canvas, a well, a cave, a mask—the garden is a receptacle for that which we ordinarily consign to symbolism. The courtyard garden unobtrusively shows us how metaphor is much easier to manage than reality. All art seems to support this basic tenet: when our senses fail to apprehend reality, metaphor comes to our rescue. For exmple, as a symbol of our mental processes, the courtyard garden stabilizes the moment of a stone penetrating the stillness of the pond, the echoing ripples stopped in the raked sand.

Since the courtyard garden is a significant part of the house, it is understandable that it also serves a symbolic function similar to the "idea" of the room for Western culture. For modernist writers early in this century, psychological enclosure

is often represented as a room within the larger house. Virginia Woolf, for example, wrote one of the first boldly feminist essays, "A Room of One's Own," wherein she maintained that all a woman needed to write fiction was "money and a room of one's own." Such a prescription for artistic creation is not confined to women nor to literature; a case could be made that everyone needs such a place to clarify one's personality (and of course the cash doesn't hurt either). Another member of Woolf's modernist "Bloomsbury Group" was E. M. Forster who wrote *A Room With a View* on a very similar theme (the view, incidentally, is of Florence, Italy, the cradle of renaissance art). Even a pop song like the Beach Boys' "In My Room" reinforces the security to be found in a room of one's own as a spiritual refuge. (Social behavior deemed deviant, such as homosexuality or recreational drug use, is often relegated to an even smaller "room within a room"—the closet. At least it used to be.)

In the West, the concept of "garden" is fraught with contradiction. On the one hand, the garden represents the human manipulation of wilderness, a taming of chaos; on the other, pristine nature. Paradise and wilderness at once appear synonymous and antithetical, like an image of a beautiful jungle but without the brutal law of the jungle to intervene. Moreover, from an Occidental perspective, the archetypal garden is both a vision of earthly paradise and at the same time a bitter reminder of human weakness and futility before God. Indeed, if our ancestral experience with gardens is any indication, it would seem that Western Civilization has programed within its sense of cultural progress the propensity to failure—Occidental culture seems to require such a dichotomy.

The Orient, by comparison, strives for a cultural and aesthetic cohesion however convoluted it may appear to Western eyes. The courtyard garden of the

Japanese machiya townhouse, nevertheless, has come to represent a similar psychological enclosure. As opposed to the "don't-fence-me-in" attitude which characterizes an unattainable notion of the wild west and unlimited open space as criteria for psychological greatness, the courtyard garden is an inner sanctum, literally and figuratively a paradigm which opens upon a psychological frontier. The courtyard garden, by virtue of its place within the house, displays a kind of contracting, retreating movement into inner space. The idea being that a courtyard garden is small enough for one to maintain the image in mind, retrievable at a moment's notice. The garden's spirit of miniaturization suggests a private world or room, personal, and unobserved by others. In this regard, personal isolation equipment such as portable telephones, personal audio devices, electronic games, etc. are technological extensions of the courtyard garden spirit in that they attempt to supply the same psychological protection and relaxation while away from home—gardens away from the garden.

IV EVERY GARDEN TELLS A STORY

Gardens are not static, however much we want them to be. They move, albeit very slowly like the hands of a clock, but they move, they guide our attention and point out directions for our confused spirits. The garden, therefore, can be a little mandala, an object of visualization. As the garden projects outwardly in the shape of sophisticated architecture, it also projects inwardly as a representation of what C. G. Jung termed our collective unconscious is suppose to look like when it is in optimum working condition—another gesture in the management of cultural memory.

We live in an age of fragmentation. Totalizing world views have been discredited in our post-modern age. To put it bluntly, since we don't believe in cohesive world views anymore—Christian, Communist, Capitalist—the courtyard garden or remains something of an anachronism, a remnant of an ancient sensibility. The garden reinforces this basic truth time and again: as a cultural paradigm, totalizing world views have become obsolete. The courtyard garden may symbolize a forsaken consciousness but it still has the ability to instruct. Isolated as it is from the outside world, the courtyard garden transcends those potentially liberating, ultimately debilitating factors of society—race, creed, nationality, language. The garden gives us a chance to become liberated, enlightened beings even in this life, as Buddha described it, of suffering, desire, cause and effect.

Not surprisingly, what we learn from the garden is that we ourselves are like gardens. We are like plots of fertile ground; we have no idea what seeds of truth will be blown over us, or which ones will take root and which ones won't. French aviator and writer Antoine de Saint-Exupéry put it this way:

> Truth is not in that which can be demonstrated. If orange trees put down firm roots and bear fruit in one piece of ground and not in another, that piece of ground is truth for orange trees. If a particular religion, culture, scale of values and pattern of activities encourage that sense of fulfillment in man, liberating within him a lord who was oblivious to his own sovereignty, then that culture, that scale of values and those activities are the truth of man.

So, if Cat Stevens becomes a Muslim, or Alan Watts a Taoist, or T. S. Eliot a Catholic, or Richard Gere a Buddhist, or Sammy Davis Jr. a Jew, the private motivations of the individual are secondary to the roles they assume in bringing truth to fruition. The quality or style of the truth which has somehow chosen us is beyond our control. To presume that we choose our destinies, or that one religion is the true religion, or that our personal God is the only true God—these conclusions betray short-sighted metaphysics. Such determined choice is a kind of philosophical hubris and spiritual arrogance.

We are like the garden when a spirituality takes root in us, is fulfilled in us. We are simply the means, our hearts and bodies merely the locale, for truth to be realized. And there are as many truths as there are seeds blowin' in the wind. Of course, we can try to cultivate a certain truth by choice, advancing a cycle which joins us with past and future generations in the continuing garden of our families and communities, yet we need not chastise those who—to switch metaphors for a moment—hear a different drummer. We have attained a sublime consciousness and spiritual maturity when we can embody a truth as naturally, as unself-consciously as the garden contains plant and stone.

We desire enlightenment and the garden shows us how to achieve it. We do not occupy or simply observe the garden; instead, the garden is our soul and, when we are able to perceive what the garden (and the home and the world) has to offer in all its clarity, then we know that God has taken up residence in us.

Further Reading

- Eliot, T. S. *Collected Poems* 1909-1962. London: Faber and Faber, 1963.

- Keane, Marc P. *Japanese Garden Design*. Rutland: Tuttle, 1996.

- de Saint-Exupéry, Antoine. *Wind, Sand and Stars*. 1939. Translated by William Rees. London: Penguin, 1995.

- Sen, Sôshitsu XV. *The Japanese Way of Tea*: *From Its Origins in China to Sen Rikyû* Translated by V. Dixon Morris. Honolulu: U of Hawaii P, 1998.

- Shigemori, Kanto. *The Japanese Courtyard Garden*: *Landscapes for Small Spaces*. Photographs by Katsuhiko Mizuno; translated by Pamela Pasti. Tokyo: Weatherhill, 1981.

- Slawson, David. *Secret Teachings in the Art of Japanese Gardens*. Tokyo: Kodansha, 1987.

- Trieb, Marc and Ron Herman. *A Guide to the Gardens of Kyoto*. Tokyo: Shufunotomo, 1980.

- Wright, Tom. *Zen Gardens: Kyoto's Nature Enclosed*. Kyoto: Mitsumura Suiko Shoin, 1990.

Mizuno Katsuhiko was born in Kyoto in 1941. Since 1969, he has been working to capture the beauty of Kyoto's natural and cultural landscape. Among his numerous publications are *Shiki Kyoto (The Four Seasons of Kyoto), Zen Gardens,* and *Masterpieces of Garden Art in Kyoto.* Mr. Mizuno has written many editorials on traditional Japanese culture. He is also a member of the Japan Photographers Association.

Preston L. Houser first came to Japan in 1981 to study the shakuhachi (bamboo flute) and Zen Buddhism. Mr. Houser is currently an associate professor of English Literature at Baika Women's College, Osaka. In addition to teaching, Mr. Houser is a regular contributor to *Kansai Time Out*, as well as reviews editor for the innovative periodical *Kyoto Journal.* Mr. Houser lives with his wife and three children in Kyoto.

42